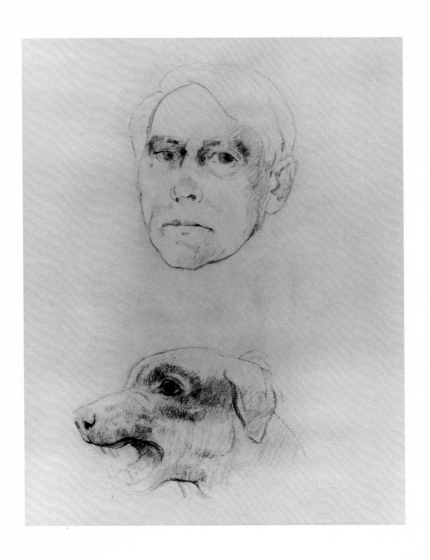

ALBERT YORK

Essay by
William Corbett

PRESSED WAFER
BOSTON 2010

to R.D., C.L. & W.K.

Introduction

"A sturdy sense of itself of being built out of its own necessity"
—*Alice Munro*

Albert York's paintings are so clear, so able to speak for themselves, that writing about them can feel superfluous if not rude. In this, York's art reminds me of the poetry of James Schuyler. Schuyler's poems say so clearly what they mean to say that interpretation seems beside the point. I want to introduce York to others who will love his paintings, and I am mindful that each word I write need not speak for York but must help the reader see what I see in his art.

"I think we live in a paradise. This is a Garden of Eden," York told *The New Yorker's* Calvin Tomkins, "really it is. It might be the only paradise we ever know, and it's just so beautiful, with the trees and everything here, and you feel you want to paint it. Put it into a design." York spoke before our period of, in the bland phrase favored by American politicians, "climate change." Seen from our volatile natural world his paintings might look nostalgic, yearning for a paradise lost. They were not painted in this spirit—York is not a sentimentalist. Design, his instinct for form, is paramount and York's paintings are, in the manner of the figures in Piero's frescoes, a Corot landscape and Cézanne's apples, timeless.

I

The viewer peers around three tulips at a distant horse and rider. The earth is bare. There is a tree in the background. It is a summer day in the country. "Three Red Tulips in Landscape with Horse and Rider" is Albert York's most radical if not his most mysterious painting. First there is the perspective—three tulips in full bloom rise up like titans, huge for the space, which at 15 3/8 x 14 1/4 inches is a large York. The tulips stop and hold the viewer drawing him toward the action. The viewer could be prone on the ground, using the tulips for cover to spy out a mysterious drama unfolding. A gallop for pleasure? Perhaps, but the forward thrust of horse and rider and the intensity with which they are being looked at suggests diving toward a finish line or flight. Where have they come from; where are they headed? Why the intense, intimate concentration on them? York offers no clue leaving you free to read the figures as you please. Or not be bothered to speculate, but enjoy the action because it is sudden, with no story attached and beautiful. The weirdness of parts and exhilarating action—bold Brobdingnagian tulips and small headlong horse and rider—are thrilling. York's every brush stroke vibrates with life, delivering a world freshly seen and compelling.

Over nearly forty years Albert York hit this high mark again and again. His subjects: landscapes, meandering streams, birds, trees, ponds, dairy cows in fields,

American Indians, flowers in tomato cans, flowers in glass vases, figures in 19th century dress and dogs at heel or walking are those of genre painting, but York's art is personal, animated by his particular blend of observation, memory and imagination. His treatment of his subjects is without remove, is more immediate and concentrated than such subjects are commonly given. At first glance you recognize these subjects and simultaneously or seconds later you see his just-right formal invention and then, a step closer, his superb paint handling. What distinguishes York's best paintings is that they are powerfully all-of-a-piece and innocent as if the artist and viewer are seeing this view or that bunch of flowers for the first time. York has rare assurance, not suave but guileless. A York is like the jar in Wallace Stevens's poem "Anecdote of the Jar," it takes dominion everywhere simply by being there, which is to say by the force of the artist's imagination. A York is itself without forethought—what stops you is the certainty of his painting, these elements here now. In Van Gogh's phrase a York is "calm in the face of even the catastrophe."

Since 1963 New York's Davis & Langdale Company, York's only dealer, has led off their checklists of Albert York exhibitions with this biography of the painter:

> BORN: Detroit, Michigan, 1928
> STUDIED: Ontario College of Art
> Society of Arts and Crafts, Detroit

To those who have followed York's work he has become known for the little we know about him. Of course Roy Davis and Cecily Langdale knew more than these facts and are very willing, Roy Davis in particular, to talk with gallery goers and York fans about York and his art, but the public record is sparse. In 1995 Calvin Tomkins's *New Yorker* profile of York "Artist Unknown" added greatly to—it practically created—public knowledge of York's life and career. York, who has divided his time since the late 1970s between Florida and Long Island, can fairly be described as a recluse. In her book *Albert Pinkham Ryder* Elizabeth Broun applied this characterization to his art, "York's paintings seem at first the simple utterances of a recluse, out of the habit of converse with society." American artists of a certain kind—William Carlos Williams was once considered this sort of primitive—are often treated as naïve in this way. Even if there's a grain of truth to it, it is true that York is one of those rare Americans to whom publicity means nothing. He has been content to live his life as an artist in private. In New York's art world unless this attitude is understood as a statement this indifference to career is commonly considered eccentric. York seems not to care. For those who love his art as I do it is natural to be avid for knowledge of the man, knowledge for its own sake and for what it might lead me to see in the art. The York cupboard may be all but bare, but we do know a little.

Soon after his birth York's unmarried parents separated, and he grew up believing that his mother was dead. His father, a Canadian who had found work in Detroit's automobile industry, unable to properly care for York, placed him in a boarding/ nursery school for the first seven years of York's life. At 14 York went to live with his father's married sister in Belleville, Ontario. As a child York drew human figures and animals with charcoal. York remembers his father giving him a good paint box

and encouraging him, but the box contained the wrong sort of brushes. They had hardly any bristles. In high school he studied with a local artist and after graduating York went on to the Ontario College of Art and Design, the first of its kind and the largest such school in Canada. There he copied classical sculptures from plaster casts and drew still lifes, a traditional first year curriculum. Because York's father brought him back to Detroit, York continued his studies at the city's Society of Arts and Crafts, which awarded him a scholarship in his second year. York got to use little of it. The Army drafted him in January 1951, and he spent almost two years in the service, some of his tour on active duty in South Korea where he had no time for painting.

Upon his discharge in 1952 York went directly to New York City. A sergeant from the Bronx had told him about the Art Students League and that is where York wanted to continue his schooling. The League's fees were beyond his means, but he found his way to the painter Raphael Soyer's evening classes being given in two rooms on West 56th Street. According to Tomkins, the Social Realist Soyer was York's "most important teacher" and his last one in the formal, classroom sense. To pay for the lessons York worked several jobs, which took their toll on him until he was too drained at night to paint with any regularity. He has shown only a few of the paintings he completed during this time, one being of two women he did at Sheepshead Bay when on a painting outing with friends. York set aside his art to labor at a variety of manual jobs, including unloading trucks in the garment district. This dead end lasted five years until York went to work in 1959—having been recommended by a friend from Soyer's class Jerry Anderson—for the painter and picture frame designer Robert Kulicke. Considered by many to be the greatest frame maker of the 20th century, Kulicke's sleek frames had a profound effect on

postwar art. He kept a shop on York Avenue at 91st Street.

Kulicke hired York as a gilder, at which trade York excelled. "I spent hours talking to him in the shop," Kulicke told Tomkins, "but I don't recall a single thing he ever said except 'Yes,' 'No,' or 'Maybe.'" York's intense shyness is one explanation for why he has kept his distance from New York's art world.

This shyness and York's quiet manner are illustrated by an often-repeated anecdote about him. In 1959 he met Virginia Mann Caldwell at an artist's party and shortly after moved in with her and her two children. She later told Roy Davis that she had no idea York was an artist until some six weeks after their marriage in 1960 when she came into their kitchen and found him sketching horses to amuse her children. When Tomkins told York this story York "looked mystified." He remembered that before his marriage to Caldwell they had spent four months in France with her children, a trip on which he had taken his paint box and frequently painted in the French countryside. It may be that York did not tell his wife he was an artist when they first met. It may also be that when they met, York, who had not painted for some time, did not think of himself as an artist. Since York is modest to the point of anonymity this anecdote seems to define him.

It seems perfectly in keeping that during the four months in the spring and early summer of 1960 that he and Caldwell and her two children spent in France York visited the Louvre once. They spent a month in Paris but York managed only the single visit because, as he told Tomkins, "The Louvre is so huge and we had the youngsters with us, and they kept disappearing." After Paris they went southeast to Sens because of its great Gothic cathedral, which York had read about in French art historian Eli Faure's books. They then spent three weeks or so in Toulon before

taking a bus toward Marseille, stopping at the village of Sanary on the Mediterranean. Where he could, York set up his easel and painted small dark pictures that have yet to be shown. (The one I've seen is of wiry mud-green bushes under a brown sky. Murk and gloom. An early indoor Vuillard of a landscape.) York remembers that in Sanary they were across a highway from the ocean, a highway they had to cross carefully because of the tank traffic—this was during the Algerian War. They spent a month there then returned to Toulon where their hopes of staying in France ended when they ran out of money. From Le Havre they sailed home on The Liberté, its last voyage. That October, York and Caldwell married and moved into an apartment on East 84th Street, and York returned to work for Kulicke at the frame shop.

During the next few years York spent much time at the New York Public Library poring over art books. He continues to do this today, "reading the pictures" he calls it, but not necessarily reading a book's text. He told Tomkins that he also "looked at just about everything at the Metropolitan." He responded to the Ashcan School painters, George Bellows, John Sloan, Robert Henri and George Luks and, in Tomkins' words, York "developed a reverence for Manet and Cézanne." York would develop something of Manet's touch and learn from the awkwardly balanced solemn forms in Cézanne's still lifes. He also developed a passion for certain old master paintings, especially Giovanni Bellini's "St. Francis in the Desert" at the Frick Museum.

But it was Albert Pinkham Ryder who had the most powerful impact on York. Tomkins reports that York remembered seeing reproductions of Ryder's paintings in "music books" he had as a child. York has since told Langdale that this is not so. Whatever his history with Ryder, he saw a show of American 19th century painters

at the Met that included works by Eastman Johnson, Winslow Homer, and Ryder's "The Feast of Arden" and "The Temple of the Mind." He told Tomkins, "The Ryders were the only ones that really held up, for me. They were so small ("The Forest of Arden" is 19 x 15 inches) but so strong that they outdid everything else in the room. The whole universe was there in those small pictures. Ryder knew how to fit together the negative and positive forms—clouds, sky, trees, the sea. He locked it all in." Exactly the words to describe York's own paintings. In his Ryderesque "Twin Trees" from 1963 (at 10 7/8 x 10 1/2 inches, toward the lower end of York's dimensions), he fits together sky, trees and a pond whose surface reflects one of the trees in a way that feels "locked in" with the authority of the inevitable. This authority is visible in many paintings York has done of trees, some with a Ryder-like snake slithering in the foreground (What is the Garden of Eden without the snake?). What York has carried over from Ryder is an animating tension in his forms, a quality of arrangement that is at once right and mysterious, a whole universe released in a small space. "Three Red Tulips in Landscape with Horse and Rider" may be, with its rider (Ryder!) and careering horse, a nod to York's master.

Throughout his career York has painted trees. They are realistic, fully leafed rounded forms, but the distance between them and the way York fits in the sky around them looks invented. Water, a pond or snakelike stream, is another element that feels, in York's phrase, "locked in." If these views were dated 1848 or 1905 the viewer would accept them. These are summer trees—it is nearly always summer in a York painting—bushy, dense with leaves, forms York clearly loves to paint. His trees have a standing still quality, not on guard but watchful, somehow alert but modest in their stateliness.

Some of York's earliest trees were painted after work in Central Park on portable small "panels"—York's word—of wood. York may have arrived at the size of his paintings, always off square and odd in dimension—10 1/2 x 8 inches to 15 1/2 x 13 15/16 inches—because the size was right for a painter without a permanent studio and because the wood, scraps really, was freely available at Kulicke's shop and later from the Long Island construction sites where York worked. Of course sticking to such a size cannot be only about convenience. A painter's decisions in such matters are as personal as a poet's meter. It is how the painter sees and how he wants what he sees to be seen. The concentration of York's paintings—they are all over *and* all at once—and their intimacy are implicit in their size. His decisions may appear to be somewhat in reaction to the dominant art world, the many billboard size paintings, of his time, but York has been consistent in a size that must be natural to him. His paint handling, on the other hand, is very much of his time, as quick, confident and luscious as Philip Guston's. (Coincidentally, between 1969 and 1973, Guston, moving into his late figurative work, painted single images—bricks, hooded figures, cups, shoes—on York-size panels.) It may be that York has been not so much against the tide of his times as indifferent to it.

In the early 1960s Jerry Anderson saw a few of York's paintings and encouraged him to show them to Kulicke who "immediately saw that it was terrific work," the work of "a great painter." Kulicke got Roy Davis, a friend since their days at Philadelphia's Tyler Art School and now a dealer, to look at the Yorks he had seen. Davis knew at once that he wanted to show York and did so in March 1963, a show that went over very well. It received good reviews, including an intelligent notice from the painter/critic Lawrence Campbell in *ARTnews*, and the paintings sold for

what sounds like a pittance, $150 to $400, but were good prices for the times. York had moved to East Hampton, renting a house there and commuting to work at Kulicke's until the commute wore him down. He quit the frame shop and found work as a house painter and carpenter in East Hampton, work that gave him a ready supply of the wood panels he liked to paint on. His relationship with the Davis Galleries, then Davis & Long, would remain, with one small deviation, into the present.

York's move to Long Island presented him with a cultivated, lived-in landscape more varied than Central Park's, which he painted in an original way. "Farmhouse, East Hampton" (c. 1964) is a view of the side of a house and its outbuildings and the trees and bushes growing close to them. It is a view rarely painted; a view countless painters in countless places must have passed but not noticed or if noticed thought not worth painting. The house is Hampton brown, a muddy shade. York's paint gleams as the house and outbuildings surely do not in life. The composition left to right is like a beautifully constructed Don DeLillo sentence—plain words moving toward clarity with a tang. The view is so offhand so surprising—it has been hiding in plain sight—that it must be indicative of the way York sees the world. The painting is so assured it looks painted without a moment's hesitation. To me this painting celebrates what we see by containing both what we miss in life, and the inevitability that we miss so much. It is York's "View of Delft."

Roy Davis studied to be a painter at Tyler in Philadelphia. He remembers his youthful certainty that he would become a successful painter, and how while studying at the Barnes Foundation that arrogance deserted him. He began to see

that his paintings were not what he thought they were, but he also began to gain an "aesthetic assurance," the ability to know, and to explain, what he liked in a painting. In 1952 Davis moved to Manhattan where he bought a townhouse on East 60th Street, opening a gallery on its ground floor. It was the first business on what today is a block of antique stores and restaurants. Davis showed the Philadelphia artists he had known at Tyler—Seymour Remnick, Aaron Shikler and David Levine. And he gave space to Kulicke to display his frames, which led to Kulicke's framing paintings for, among others, Mark Rothko and Willem de Kooning.

Then as now East 60th Street is outside the New York art beat. It is fitting that this is where Albert York began showing and still shows paintings that in size and subject matter are so far outside the art of his celebrated contemporaries. York had the good luck to find in Davis a dealer who has championed his work. I saw my first Yorks at the Madison Avenue gallery. (My memory is that I was gallery going and chanced upon the show.) There stood Davis in his uniform of corduroy pants and sweater, long cigar in hand. In answer to my questions—he must have known at a glance that I was not a collector—he talked at length, emphasizing in clear terms what he saw in York's art. I don't remember exactly what he said but the delight he communicated, the pleasure he relished in looking at and talking about York's paintings, has stayed with me ever since. Over forty years after giving York his first show, Davis and his wife Cecily Langdale continue to mount York shows even though not a painting is for sale. They beg and borrow to put together these mini-retrospectives in part so that they can once more enjoy talking about York's work to collectors, new viewers and devotees who cannot get enough of York.

Between 1963 and 1992 Davis gave York a dozen shows. York sometimes brought

his unsigned, untitled and unframed "panels" to the gallery in a paper shopping bag. Later, when he lived on Long Island and came to the city infrequently, he several times wrapped paintings in brown paper and sent them to the gallery by U.S. mail. His last painting, a still life of flowers, arrived at Davis and Langdale in 1992. Since then he has sent only drawings.

York's shows received good reviews and sold well, but he paid no attention to what most artists think of as their careers. He did not meet critics or collectors, even famous ones like Jacqueline Onassis who owned five York paintings, nor did he seek out other painters. Then as now Roy Davis has handled York's relationship with the art world. Since the 1980s Davis's wife and partner Langdale has kept in touch with York by phone. He has not come into Manhattan for the several retrospective shows mounted by his gallery, nor has he been interviewed since he spoke with Calvin Tomkins. I have never spoken to or seen York. I would like to hear his voice, see his hands, gain a sense of him as a person, but I've never attempted to get in touch with him nor have Davis and Langdale offered to introduce me.

In considering York's achievement it feels necessary to account for what he has *not* done. His indifference to titling—titles are for identification alone and have been supplied by Davis and Langdale—and dating his paintings at first seems significant. York may have completed upwards of 325 paintings—there is no accurate count—which means that he has worked slowly, producing on average of 12 to 15 paintings a year during the years he had shows of new work. A slender output that because of his indifference to record keeping must be charted chronologically by the use of "about" as in "Flying Figure in Landscape" (c. 1968). But the more York paintings you see the clearer it becomes that accuracy in these matters is academic at best.

His art has not grown or developed in the conventional sense of these concepts. Paintings from the early 1960s like "Twin Trees" and from the early 1980s like "Landscape with Man in Armor, Crocodile and Indian" are of a like quality. York has painted beautiful pictures throughout his working life, pictures that when placed side by side at a retrospective show are different in subject matter but similar in every other regard.

York's inspiration has not been constant and certainly there are weak paintings, but his art is not one of peaks and valleys. His art is a line, interrupted at times, but similar in size, scale, intensity of focus, paint handling and presence. This suggests, despite the doubts he would express to Tomkins, that he has maintained faith both in his means and vision. His paintings need no title to direct the viewer's attention. They might have been painted in any decade of the late 19th or 20th century and prefer anonymity. If a collector requests it York will sign his paintings, and he signs them on the back. Modesty? Yes, but this is also an aesthetic choice that puts the painting first, unencumbered by a signature. Throughout his painting life York has remained absent from the art whirl. It is tempting in writing about York to find virtue in what he has not done or refuses to do. Perhaps it is best to see that York has the arrogance, a quality Roy Davis found lacking in himself as a painter, to make his art exactly as he pleases.

Davis thinks so. Yet in the Tomkins profile York constantly finds fault with his work, sees it, except for a single painting, as having fallen short of his intention and hopes. Tomkins quotes Robert Kulicke as saying, "What Al doesn't understand is that in art you never hit what you're aiming at, but the difference may not be downward." Davis thinks York has hit the mark many times. His evidence, like

Kulicke's, is York's paintings, which both men see as incomparable. To illustrate the sort of intuitive command Davis sees in York's art he tells this anecdote.

Years ago Davis sat on the porch of his father-in-law's country house. While the two men talked they watched a kitten playing in the grass near a milk bottle. The curious kitten stuck its head in the bottle and unable to get it out, panicked and began to flail, clearly suffocating. Davis froze but his father-in-law, a renowned Manhattan surgeon, picked up a rock and smashed the bottle setting the kitten free. In York's art Davis sees exactly this sort of decisive act.

In 1972 York learned from his dying father the stunning news that York's mother had not died but was alive in Florida. Having reestablished contact with York's father she wanted to meet her son. York described that meeting as "rough" but he and his mother somehow built a relationship. After York's father's death they went together to Canada to settle his estate and there he painted her sitting in a field of grass, a favorite York composition at least since his visit to Sheepshead Bay many years before. York's mother turned out to be a successful real estate broker in Florida and after a few years she created a trust fund for York from which he received a small income—enough money so that in the years to come he provided fewer new pictures to Davis & Langdale.

After York visited his mother in Florida, time spent there entered his work in one funny and marvelous way. A crocodile crawls into several pictures, joining in one an Indian brave and a man in armor, perhaps representing one of Ponce de Leon's conquistadors. The figures appear to have suddenly encountered one another or just walked on stage. The action takes place against a background of Long Island summer trees. The viewer is free, as with other Yorks that portray Indians (York's

Indians are not "Native Americans" but belong to another time) or Saracen warriors on horseback or men and women in 19th century clothes, to invent your own story. There is also a portrait of a palm tree from 1990 painted in bravura strokes. Owned by Davis & Langdale, it is one of their favorite Yorks. A lush world of browns and greens close in value, lit by a wash of moonlight "Moonlit Landscape with Palm Tree" was painted by a brush that loved its work. Today York winters in Florida, and one of his recent drawings depicts a woman, mouth opened perhaps in song, and below her a crocodile (I'll stick with Roy Davis's identification of the beast) whose jaw line suggests a crooked, sardonic grin.

At some point in the early 1970s the painter and first-rate art critic Fairfield Porter, who lived in nearby Southampton, took an interest in York's work. They briefly became friends, York seeing Porter two or three times and visiting his studio once. In December 1974, eight months before his death, Porter wrote a two-paragraph essay on York's work. Davis & Langdale published this in their catalogue for York's show of October 12–November 6, 1982. There were 47 pictures in that show, many dating from the 1960s, only nine of which were for sale.

Porter's first paragraph is about "our present day wide-spread discontent." He attributes this to the scientific method by which he seems to mean technology out of control, at that time a bee in Porter's bonnet. He proposes York's paintings as an antidote to our malaise and a corrective to what Porter calls "an objectivity whose purposes are not ours." Porter observes astutely that "He [York] identifies with his subject, whether a tree, a cow, a glass of flowers, or the woods. But not only with the subject: he also identifies with his materials, and with the translation of the identification with the cow into an identification with the paint he uses to present

the cow." There *is* a seamlessness in York's powers of observation, imagination and execution. He *sees* in paint. Porter ends on another just right note:"He [York] does not 'know' anything better than you who look at the painting; rather, he is able to identify with the mystery of the world that our civilization tries to keep us from being aware of." Like myself and so many others, Porter responds to the mystery in York's art connecting it to the larger mystery in which we live.

On November 26, 1982 the only large-scale museum show to feature York's paintings opened at Boston's Museum of Fine Arts. *Contemporary Realist Painting: A Selection* was designed to accompany Fairfield Porter's first retrospective, which opened later, and ran until February 27, 1983. There were 46 paintings in the show including work by Alex Katz, Willem de Kooning, Jane Freilicher and Richard Diebenkorn, all represented by single paintings. York's former employer Robert Kulicke had two paintings in the show and York had 21! A checklist of this show exists, but there was no catalogue and only the sharp-eyed John Russell in a *New York Times* review of the Porter exhibition seemed to notice the show. He urged his readers not to miss it. I myself live in Boston and got to see the show several times, the sole chance I have had to see York's work in company with that of his contemporaries. I remember being bowled over and returning several times, but I kept no written record of my reactions.

Among the Yorks on view was "Landscape with Two Indians" (1978), a gift to the MFA from a purchase fund administered by the American Academy of Arts and Letters. Mid-size, and typical of York's found scraps of wood, eccentric in dimension at 12 1/2 x 10 11/16 inches, the painting was described by the museum's newsletter as a "tiny allegory" in the manner of Maurice Prendergast and Albert Ryder. In the

late 1990s, writing on York for the magazine *Modern Painters*, I tracked the painting down in the MFA's basement where it had been stored since being exhibited. The employee who showed it to me, herself about to leave the museum because of a shake-up brought on by the new director, told me that the York would never hang in the museum again. She gave no reasons but spoke in a flat, authoritative way, and to this day the York has remained in the basement.

Around the same time I visited Cleveland to give a poetry reading and got to see the Cleveland Museum's York "Bird with Dead Moth," a gift from its owner to the museum at the request of former director Sherman Lee. The current director Henry Adams showed the painting to me, where it was hung in a morgue-like back room. The bird, possibly a sparrow, is monumental in the painting's small space and rules over the kingdom where the moth has died. Nature, the painting causes you to think, has its own sense of scale. I remember Adams, having not seen the painting in some time, quite liking what he saw.

The only York I have seen hanging in a museum is the mythical creature "Flying Figure in Landscape" (c. 1968) at the University of Nebraska-Lincoln Sheldon Memorial Art Gallery. At present New York's Museum of Modern Art owns two Yorks, a gift of the early and committed York collector Werner H. Kramarsky. They have yet to appear on the museum's walls.

"Bird with Dead Moth" has York's sweet temperament despite the macabre moth. "Flying Figure in Landscape," based on a figure from Indian, presumably Hindu, mythology is unlike any other painting by York that I have seen, but "Landscape with Two Indians" distills York's special "mystery." Here is what I wrote about the painting for *Modern Painters*: "Like many Yorks it is not painted to the edges and has

an unfinished look. Two Indian braves stand far enough apart so they are figures in a composition, imaginary Indians not to be confused with the real thing. The season is summer, York's favorite, and the braves are posed in front of two full-grown trees. (This playing with scale is but one of the 'wrong' notes he likes to hit, wrong in the sense the composer Charles Ives meant when he warned his copyist to stop correcting them with the admonition, 'All the wrong notes are right!') Crawling across the ground in front of the braves is a worm-colored snake, brother to the one in Albert Ryder's painting *The Race Track*.

"If this painting is a 'tiny allegory' and allegory is a term often hung on York's work, it is not easy to say what it intends. This mysteriousness, as with so many Yorks, adds to the painting's aura and the viewer's pleasure. One possible reading of the two stolid braves is that for Americans the Indian is such a mythical figure that it is impossible to see him as anything but a character in a story. Another possibility is that whatever the American landscape—this one is as flat as the potato fields near York's Long Island home—the Indian is always present, reminding Americans of this continent's first human inhabitants and their bloody near annihilation. The snake? The snake could be read in a host of ways. Perhaps it suggests, above all, that the beauty of such allegories as York commits is that they do not have to come out even, and like Stevens's jar they are a 'port in air' [I quote from Wallace Stevens's poem "Anecdote of the Jar"] to be emptied of many possibilities."

I see now that I left out the pond behind the Indians and between the trees. I see too that I failed to emphasize that the Indians are too far apart. They are not "together" and neither are the trees. It is in the space between them where the mystery lies and it would be there if the figures were women in bathing suits or

two baseball players. There must be other painters who use the space in-between in this way, but from the earliest tree paintings it is an area of subtle disturbance for York. Through Cecily Langdale I queried York about the many Indians in his work. Were they related to a specific memory? Did they descend from the photographs of Edward S. Curtis or from Western movies? He replied that he made them up.

In 1989 the curator Klaus Kertess approached Davis & Langdale proposing to put York in a show of three Long Island landscape painters, Jane Freilicher and April Gornick being the others, at Southampton's Parrish Art Museum. The Davises thought the show a fine idea but cautioned Kertess not to get in touch with York about it. They feared York would refuse to take part. They may have been right for when York saw the show shortly before it closed he came away in despair. "It's pretty lousy—pardon the word—work," he confessed to Tomkins, "Pretty bad. I don't recognize myself in these things. It has no relation to good painting. I don't recognize myself in these things. I would like to do better. But, of course, it's there, and probably I will never be able to change it."

York spoke disparagingly of several paintings that those who love York's work rank among his very best: "Woman and Skeleton," "Reclining Female Nude with Cat," and "Three Red Tulips in Landscape with Horse and Rider." Most artists have periods when they see their art in a harsh light and are convinced they have failed. Tomkins felt that, in his words, "York's notion of an acceptable painting hovers somewhere near the level of Bellini's 'St. Francis in the Desert,'" and that this explained York's attitude. He also wondered if York genuinely does not know how good a painter he is. A bad day? Unreachably high standards? What Tomkins thinks of as "naiveté?"

Hindsight suggests that something else can be added to the mix. "The Parrish show stopped him [York] in his tracks . . . and he has been struggling to find his way again. 'I just don't know exactly where I am now,' York told Tomkins, 'or where I'm going.'" Perhaps York's response to what he saw at the Parrish was a premonition. Three years later he would send his last painting to Davis & Langdale. In saying, "I will never be able to change it," York may have foreseen that for whatever combination of reasons he was about to stop painting or stop completing paintings. At this point we don't know what York thought but if he did speak from foresight this may have blinded him to the consequences of his past decisive acts.

Most artists suffer through a similar neurotic view of their own art even if that view is momentary, and these dark moments are endured as part of the struggle. Some artists even find resources of energy and imagination in their doubts. This may have been true of York. He expressed doubt about his work to Kulicke and to Davis and then painted some of his best paintings.

For a painter to stop painting is inevitable, but we indulge the romantic notion that his brush drops from his dying hand. That York may have run out of inspiration or found himself in a place, trapped, he could not see his way out of, says little about the paintings that he painted before this time. Because Davis & Langdale have mounted four York retrospectives—1998, 2001, 2004 and 2007—his paintings have remained on view and fresh in New York. There have always been viewers who are seeing York's work for the first time. That seventeen years have passed in which we have seen but a handful of new York drawings cannot diminish York's achievement. Indeed, his admirers want more Yorks because what he has already given us is so captivating. We would love more Pieros, Vermeers, Ryders, Gerald Murphys—the

list is long—but to want what we do not have misses the point about art. Picasso is not the point. He was, he said, like God: he could create the aardvark and the elephant—he could do anything! The point is that the vast majority of artists in any medium are given only so much to make, say, an inch or two, but within that space the best artists concentrate everything.

Everything for the viewer that is, but perhaps not for the artist whose need is different. Tomkins and Kulicke pointed out that York's ambition and his understanding of his art, what he hoped to accomplish, were at odds with what others saw as his accomplishment. Elizabeth Bishop spoke of this divide when she wondered if she would ever write "the real poems"—those the poet can envision and almost taste but that the completed poem never reaches. For some this conflict is the engine that helps them produce the "everything," the simultaneity of means and ends we find in so much of the art that engages us. However it was managed, this quality is what we return to and in the paintings we love it feels inexhaustible.

II

"A painter can say all he wants with fruit and flowers."
—*Manet*

The Yorks I love most are his flower paintings. There are two kinds of these. He sets flowers in vases, tin cans or water goblets outdoors on bare ground or grass. Trees, bushes, sky for background. Or he bunches his flowers in a tomato can or vase on a flat surface against a background color as if to paint their portrait. In some of the later paintings a table and room can be conjectured. York's flowers are common—roses, anemones, violets, dandelions, geraniums, poppies, zinnias and impatiens—but his placement of them is uncannily his own. This subtlety is difficult to put into words, a slight tilt to the flowers and vase or unexpected scale when out of doors. Uneven construction gives his forms life. His paint handling is fluid, tender, discreet but unfussy and quick, so that it expresses York's discovery of his design while communicating a love of seeing for its own sake. The beauty of shape, texture and color that we love in flowers—York's flower paintings have these attributes.

The sort of flowers York paints are cultivated and civilized, citizens of the Garden of Eden he believes our world to be. Yet his paintings have an impromptu air that doesn't present flowers as declarations of love, wishes for good health or festive

decoration. His flowers look unarranged, an instinctive act of gathering beauty—you feel York wants to see what they look like as much as you do. The emphasis is on strong plain forms, flowers we have seen but not in this way.

The paintings give us reds, pinks, and blues—"Red and Pink Roses in a Blue Can in a Landscape" (1983)—yellows, geranium reds, empurpled unopened roses like ripe red wine grapes, pale red and blue anemones with their lacy collars, highway caution orange zinnias, marigolds, white roses and impatiens. His colors are more straightforward than bold, neither souped up nor slavish to the flower's natural hue. York's eye is not distracted by botanical accuracy. He more embraces the forms: spear leaves, feathery and cut out petals, urn-like tulips and the myriad of shapes that excite him.

"Landscape with Red Roses in a Glass Goblet" (December 1983)—the goblet is thick and heavy, a 19th century water goblet that sits canted slightly to the right. No water is visible in it. York likes glass vases and he likes to indicate that there is water in them without actually painting the water. The roses are giants in the empty brown landscape with an afternoon blue sky above. Or, as with "Three Red Tulips . . . ," the viewer is on their level looking up and their scale is a matter of perspective. The same is true of the red and pink roses in their blue can, and the landscape they stand in is summery, stretching back a good distance with trees framing the scene. In both paintings the flowers have yet to unfold. The tulips are in full cup and the roses have just been picked, their tight buds just painted, their blooming more potent because York lets you imagine it.

The tomato cans York likes to employ, some with lids bent back and still attached but without detailed graphics on their labels, suggest a whatever's-at-hand

improvisation. The flowers may have been separated a bit, given a rough arrangement, but what matters most is that the moment has been seized and the bunch (there are few bouquets in York's world) has been concentrated in oil paint. De Kooning believed that oil paint was invented to paint human flesh. York captures the flesh of roses and carnations and gives all his flowers a graspable physicality.

What are flower paintings in a world of Iraq, Afghanistan, suicide bombers, Mexican drug lords, Darfur boy warriors with assault rifles, smart bombs and leaders who are liars and fools? What are small paintings of flowers in the face of this reality?

They are instances of the beauty humans ceaselessly make, beauty that is its own reward, beauty that disregards our woes and is inexplicable, deep and clear. We are ground down and coarsened by the world's daily horrors. York's flowers remind us that beauty is here too and stillness, moments for rest and meditation, moments apart to think about and feel what is in the world independent of the human urge to command and control. Moments to wipe our minds clean and to refresh ourselves. York goes about it quietly but his aim is to exalt. His flower paintings excel at standing still and staying put. The power of stillness his paintings radiate is joyous, deeply satisfying and grants us rest from the clamor.

The world rushes along leaving history, the 1950s, 60s, 70s and 80s when York painted, decades that are already so distant and now so drowned in information that we struggle to gain even a minimum understanding of what went on during them. York's paintings of trees, ponds and streams and his flower paintings, like all great art, are immemorial. They can be neglected and misunderstood or destroyed by striking a match, but inherent in them are qualities that endure because they give life value. History leaves us the mess, always in flux, currents and forces to chart, study,

contemplate, read and interpret then reread and re-interpret—it's endless, engrossing and bewildering. The value in a York painting of flowers is its consummate thereness, a thing we look at and feel what we feel without resort to argument. We don't need to be convinced; we are moved by what we see.

"**To arrange is to fail.**"
—*Fairfield Porter*

For York to arrange has been to succeed. He has arranged in two ways. The flowers he placed in landscapes use the landscape like a stage set. The cut flower displayed is a human invention. There is wit in returning to nature, transformed, what has been nature's. The other way York has arranged is, in effect, to paint a portrait of flowers in a vase. The background can be off-green, cornmeal yellow or light brown, with the vased flowers posed not as décor but for their own sake.

Why do York's arrangements succeed? They are natural and painted with total conviction. The flowers are not prettified. They have no sweetness about them nor are they delicate. Their beauty is uncompromised by sentiment. York does not attempt to elicit our sympathy: these flowers belong where they are, having been placed with a certain nonchalance yet painted with lavish strokes and total attention. It is this concentrated attention which York gives to his viewer.

Dogs, Cows, A Pigeon, A Cat

Horses are frequent in York's world, and sometimes they have riders. There are a stork, beetles, a number of small birds and crocodiles that look like props in a play. They could be made out of rubber. York loves animals but does not present them with George Stubbs's Cinemascope melodrama, nor does he look for archetypes, as did Picasso. York has owned dogs; Labrador-sized mutts based on the evidence of his paintings. He has painted several portraits of seated dogs. (As elsewhere York can be credited with a sly sense of humor—he knows how to get dogs to "sit" for their portrait.) "Four Dogs" depicts dogs in a fight or rough play. Dogs also show up as they do in life. Or in a great short story, the dog observed so that you see him with pleasure and read on captivated. Her dog accompanies the woman out for a stroll in the moonlight and one of the women in "Late Afternoon" has her dog, perhaps a Weimaraner, by her side. There is a grey dog seen from behind looking toward the woods, having heard or glimpsed something. York's affection for the dogs he paints is matter of fact. You feel he likes their company. It is another instance of York knowing how to fit what is in front of him into his design, so that we feel that what we see is intuited and inevitable.

Some of York's cows are seen in profile and some turn their archaic heads toward the viewer. All of York's cows have a blunt, foursquare physicality. (Ryder too painted cows, sometimes in groups and often in landscapes with houses and barns.) They are here to chomp and slowly masticate grass and to wearily trudge home to be milked. They are basic, and we depend upon them. York gives his cows dignity. They do not know nor do they care that they serve man, that their shit is of such great value we have a lovely-sounding word for it, manure. Cows that advertise

milk like Elsie Borden are feminized creatures mooing their delight in providing us with moo juice. York's cows, like so many of his subjects, advertise nothing and are not allegorical figures but here for their animal fact. Their mystery is related to their clarity as physical beings, which is not the same as clarity of meaning. In the force of their homely, simple presence York's cows are somehow not of our world but observers taking it all in.

York's pigeon is plump and with orange claws firmly planted on the ground. He fills the space, one eye wary, looking out for trouble. He has the nobility of a survivor. You can't drive him off with a plastic owl. He is common, the color of industrial smoke and soot. He may be a pouter his chest puffed out pompously, comically eager for his medal, but he's nondescript, just a pigeon like the thousands who peck for crumbs and flap up from the walkways of city parks.

Before York this pigeon has been one of the mass—this is a portrait and you get to look into his orange-rimmed eye and study his downturned beak. Show pigeons have surely been given this attention, but, while no bedraggled flying rat, York's bird is brother to the city nuisance and pest. York must have painted the bird for his own amusement. It's a cranky, stubborn image you wouldn't be surprised to find in a secondhand shop, the work of someone, you might guess, who'd never seen a painting of a pigeon he could believe in and decided to paint one to see for himself what a pigeon looks like.

The critic Michael Brenson sees the cat looking out at the viewer in "Reclining Female Nude with Cat" (1978) "as big as a wolf, and it is not so much the woman's pet but a guardian." The cat balances York's version of Manet's Olympia while raising the possibility of a "You lookin' at her?" joke. York's painting is comic and sketchy,

the brown and white background unfinished as if once he had painted the woman and cat he had his Manet imitation and needed to go no further. The woman is casual, her hand resting on her sex. Brenson sees this hand as a snake and thinks there is violence in this picture. The woman playfully and, to my eye, saucily dangles her left slipper about to kick it off in a whoopee, "this moment is mine," gesture. She wears a red flower over her right ear and her gaze is sexily straightforward, confident in her allure. She could be a housewife but is not a courtesan—she wears no jewelry or sexy velvet ribbon at her neck—with a maid and admirers who send flowers. She takes no notice of the cat that emphasizes by his scrutiny of the viewer that we are looking at a naked woman.

It is a big housecat, perhaps a British Blue Short Hair that has wandered into the tableau, seen the artist and stopped to fix, as a cat will, his gaze. The woman too has a fixed gaze, but it's more matter of fact than seductive—Manet's Olympia as imagined by a painter who lets his model take things for granted. Brenson thinks York's painting is "subversive," a term that has slipped into cant. To me it is humorous, a dream of Manet's woman as a household goddess. She's indulging the painter and the viewer, but she and her watchful cat know who is in charge and where this pose will end. It will not end in sin for her pose is more indolent than seductive—carnal pleasures are not necessary to fulfill this lady's desire.

In actuality there was no woman, no model posed for York, and his wife refused to. "I didn't copy it," York told Tomkins, "Just painted it from memory. That's why you get that clunky figure." York dismissed the painting as "like a student's piece of work." Clunky? Yes, that is part of the painting's charm. But the cat, that is not the work of a student. It is as alive and strange as the pigeon or one of York's stolid, faithful cows.

Men and Women

There is a York panel of two men in 19th century clothes and broad brimmed hats talking as they take a walk. I imagine they are hatching a plot. One of them is Kincaid, the name given to so many crooked assayers and land agents in Western movies. The other is his henchman who does the dirty work. But they could be two ordinary gents out for a stroll with nothing on their minds but friendly conversation.

Some of York's oddest paintings are of figures, deadpan stock characters in costume. What are those two Saracen blades doing? The one in white points his scimitar down so that his companion will see what? Or is he declaiming a point? Is this a memory from a Crusader story seen in childhood in sepia rotogravure? (Ryder painted "The Scout," a Saracen warrior.) And the Indians, red-clay men, braves and chiefs, posed as if asked to by an artist who happened upon them? They are rigid—they have posed this way before. They are from our common history and our childhood. (York knows that these are often the same thing.) All these Indians are is a pose, no longer active in the white man's memory except as characters for which baseball, football or hockey teams are named—Braves, Redskins and Black Hawks. They are symbols of everything that becomes a symbol, and we can read much into them. They may be here to incriminate us, reminding us of a past we Americans cannot and do not want to outlive. But York's Indian pictures are more matter of fact—they have the appeal of the familiar—and more suggestive of story or tale than indictments.

There are snakes everywhere in York, descended from the Garden of Eden through Ryder. Richard Cowdery, a friend of York's at the Davis & Long frame shop, which superseded Kulicke's in the same location, posed for York's snake

handler pictures. He has a widow's peak and is naked from the waist up when on dry land, an agave cactus beside him, or he wades in lake or ocean water. He might be York's version of the Laocoön. In "Man Holding Snake" (1977) the mustachioed handler holds the twisting snake by its head away from his body to admire the reptile or to demonstrate his dominance. These York images are independent of particular meaning. If you knew the man worked in a circus sideshow or belonged to a religious cult, these images would be no more powerful or strange than they are.

The same may be said of the woman seated next to the stork. The picture's forceful juxtaposition—not surreal but memorably improbable—emphasizing creatureliness may be the meaning if there is one on offer. This strangeness is also true of York figures that are easier to read. The woman in the long dress and flower crowned hat looks to me like she is singing to her dog in the full moon's light. They could be on their way from a party or she may just like to dress up when she goes for her nighttime constitutional. The painting has a full moon magic air in it. Like so many Yorks the lady and her dog appear to be complete in themselves, rendering before and after immaterial.

To me the most moving of York's figure paintings are those of two women together in a field. York saw the women in "Figures in a Field" on a painting trip he took with painter friends to Brooklyn's Sheepshead Bay. Two women sit, backs turned to the viewer, in sawgrass covered dunes looking, perhaps, to the sea that we cannot see. You can imagine the intimacy of their conversation and their silences. They are deep in one another's company.

In "Late Afternoon" (1963) we are closer to the two women depicted and though their intimacy is more immediate they could be talking about anything. What is more

human than going for a walk with a friend and stopping to enjoy an attractive, remembered or discovered, view? There is a shorthaired dog near her mistress. The trio sit in a verdant meadow of dark green grass. The woman on the left has just turned to the one on the right. They could be having a heart to heart or sharing deep gossip or just the nothing much that we exchange with friends. The women look stimulated and comfortable to be in such a wide-open space, elemental as the elements themselves.

"Two Reclining Women in Landscape" (c. 1967) is the essence of summer and a sweet-humored, thoroughly satisfying painting. (It is a mid-size York 10 x 12 inches whose nearly being square adds to the painting's impact.) The girl in summer white lies flat on the grass looking sideways at her friend. She could be giggling. Her friend holds a flower from the bush behind them to her shingled black hair, an impromptu model's pose asking for a response. She is the painting's focus—wing of dark hair, open and pretty face, lipstick, mustard sweater, short skirt and comely legs. The flowering bush, quickly painted, luxuriant, fills the background and is dark green like the grass. It's an out-of-the-way spot, a private pleasure. These girls are completely relaxed, amusing each other and pleased with their enjoyment of themselves. Summer's largesse. York nailed this one.

York has also painted mythic figures like "Liberty Figure" at 8 1/8 x 5 3/4 inches one of his smallest pictures, on tin, a votive object. He painted "Artist with Three Muses," in which the artist being instructed wears a three piece suit as correct as a small town banker's—this painting could adorn the rotunda of a 19th century library—and he has painted at least one mythological figure, "Flying Figure in Landscape," which belongs to the "one-of-a-kind" category.

In his self-portrait drawings, drawn with a broad, light line, York appears square-headed and square-jawed with a wing of hair falling across his forehead. I have seen photographs of York taken in his sixties, his brown hair going gray. He is a handsome man who could be the younger, taller brother of that Dutchman painting on Eastern Long Island, Willem de Kooning.

Landscape

It is easy to imagine the young Albert York in Central Park standing in front of his easel, painting a tree. It is hard to accept York's paintings of trees standing alone, beside a pond or with a stream winding between them as paintings of real places, findable on a map or able to be visited during a walk. York's trees stand like sentinels and have a purpose about them. Their air of unreality is in their posture, as if the trees had stood for their portrait. York's streams too are real but not realistic. They are in their S-curves an image of streams from deep in our common cultural inheritance. York may have been inspired, at least in part, to paint these pictures through his absorption in Ryder's paintings. This seems plausible because his tree paintings are less observed than imagined. Or what he observed became transformed as he imagined it in paint.

These paintings are not mysterious in a commonplace way. They are clear and easy to grasp but are not dreamlike in their clarity. What you may feel in looking at them is that York put everything he had into them, so much so that he crossed the line separating seeing from vision. Not vision in the grand sense but seeing unrestrained by mere appearance, an instinctual faculty that does not argue but asserts, albeit in York's case quietly. York put into these paintings the wonder we

experience when lost in looking; wonder that in its sudden and inexplicable arousal by light, color and form is mysterious. We do not need to know why but we do need to look, and this York's tree paintings declare in their even-tempered offhandedness.

There are York landscapes that are worlds in which his imagination has placed objects and figures. There are other landscapes, "Landscape with Three Trees and Fence" for example, that the viewer knows he has seen somewhere, perhaps from a car or train window. These are not places—they are too humble to be named—but in York's touch compressed sensations of the actual into color and form. If you never saw these landscapes in person you have seen them now, and the feeling they deliver is the delicious pleasure of immediacy. That it is impossible to separate this York painting from what one has observed and remembers activates the imagination, settling this pleasure into mind and spirit.

Edge of the Forest, c. 1963
The Meadow, East Hampton, c. 1963

Green. York's is a green world. He told Tomkins, "I'm a black-and-white painter. Well, light blue and dark green. Raphael Soyer tried to get me out of it. There are no reds in there, no oranges, no complement to the blue." I wish Tomkins had persuaded York to say more about the black-and-white of his light blue and dark green.

"Edge of the Forest" is a wall of green. As your eye adjusts you see into what at first looked impenetrable and the forest subtly vibrates. York's brush strokes take you into the color and the thin tree trunks stand out. York must have said to himself, "I see it all in green." No complements necessary.

In "The Meadow, East Hampton" five trees are spaced without apparent rhythm, and there is room enough between them for a meadow in which the mind is free to wander. Black and white is the sense of absolutes? York's art *is* absolute, no other way. He could have put Indian paintbrush, speedwell or buttercups in this field. What would have been gained? Realism? Meadows *do* have flowers in them. But York's picture has the coherence of forms he admires in Ryder and the mystery of the way the trees define a space. He didn't need more color for that.

One-of-a-Kind

York has rarely stepped outside his range of subjects, but when he has he has painted some of his strongest, most memorable paintings. The pigeon is one and so is "Two Houses, East Hampton." He has painted nothing else quite like "Three Red Tulips in Landscape with Horse and Rider" where his signature elements—flowers, trees and figure—are in play, kinetic and seductive.

"Flying Figure in Landscape" (c. 1968), shown in two Davis & Langdale retrospectives, may be York's strangest painting. The figure, an unidentified Indian goddess, holds in her right hand the bunched corner of her cloak. It's a sort of sail that keeps her airborne. Since the sky is yellowish and the earth below her green and black the time of day is indeterminate but it feels like early morning. The fur-legged, goat-footed goddess could be returning from a night of carousing.

She is unique in York's work being, insofar as I know, the only figure from Indian myth. But she is strange because it is impossible to say what meaning she has for York or do more than guess at what we are to read into her. Of course she doesn't

have to be anything more than she is. Perhaps he just liked the thought of a flying half-woman/half goat. She is alien and yet painted with York's customary conviction the goddess is a credible fantasy. She flies into our mind and stays there, a wonderful figment related to the Greek harpy but not loathsome or monstrous. She flies above, eyes closed, benevolent on an errand fit for a goddess, her left hand held out as a sort of sign, perhaps a blessing.

When York moved to East Hampton in the early '60s the town was surrounded by broad, flat potato fields. These fields are now built up, overbuilt with mansions, some of which are the size of ocean liners. York has rarely painted these fields but his old fashioned red "Wheelbarrow" (1974) sits in one that runs level to a distant stand of trees. This is the sort of wheelbarrow with detachable side panels. The panel facing the viewer has been propped upright against the wheelbarrow. It is one of York's great images of repose. "So much depends . . ." William Carlos Williams begins his poem to the red wheelbarrow in *Spring & All*. How much depends? Enough so that its quantity is beyond inches, quarts or pounds, beyond measure—it is *so* much, more than we will ever accurately know or can say.

York's painting is as matter of fact as Williams' poem. We see the wheelbarrow for what it is, contours, shape and color pleasing to the eye. We are free to think about the utility of this wheelbarrow, the hands that have gripped its thick handles, what has been lifted and wheeled to the field's far corners and to speculate on why the wheelbarrow sits abandoned, like so many farm implements that are left lay around farmhouses and barns, the moment their work is done. Barrow is from the Middle English and means "a flat, rectangular tray or cart with handles at each end" and "a large mound of earth or stones placed over a burial site." Even the ordinary is monumental—the barrow

stands with no man's name on it. Especially the ordinary, when we see that it holds the memory of work, much of it repetitive and boring, so much has been done, so much more to do, so much more lifting and hauling to survive.

The sleeping figure in "Landscape with Sleeping Figure" (c. 1968)—13 7/8 x 12 7/8 inches—is a woman; a wrap covers her from her breasts to just above her knees. She could be asleep in her bed dreaming the world we see her in, a landscape of trees, a stream and small hills receding into the misty distance where valleys hold up-drifting fog. It is gray morning just before dawn. You can hear the first bird song. Some Yorks have the heightened clarity of dreams, but this is the only dream picture I have seen. As is York's habit this is an everywoman and green, here a black-green, dominates as in so many Yorks. He told Tomkins that he painted in his East Hampton basement studio early in the morning just as the sun rose and spent its few minutes coming in through his basement window. But this was in the late '80s and early '90s, close to the time Tomkins interviewed him. There is no reason to assume that "Landscape with Sleeping Figure" was painted before dawn, although it has the look of an image York woke up with in mind and had to paint at once. How simple the imagination is, really, a woman sleeping outdoors. Had we been out for a walk and discovered her we would probably be surprised to find her there, perhaps alarmed and would certainly have looked closer, fascinated.

York's art is mostly too solid and of the moment to be called lovely, the adverb is too softly caressing. But the upper air in "Landscape with Sleeping Figure" trembles delicately and the dark around her is discreet, protective. Something—defenselessness?—embraces a sleeping person. This is a lovely painting.

Absent

I imagine York painting a car black and squared off but have never seen a car in one of his paintings. His world is on horseback.

To my knowledge he has not painted a freestanding house or row of houses.

He has not painted a country road.

Telephone pole.

Farm implement other than a wheelbarrow.

Hammer, pliers or screwdriver.

Fruits or vegetables.

Bottle.

Book.

Where is the 20th century in York's art? The dress of a woman leaning on her elbow in a green field. Sleeveless, vee neck and a green sash at the waist?

Is his Eden perpetual summer? Do fall and winter hold no allure for him? His winter is the Florida palm tree but never snow or ice.

Rain.

Rowboat. Ocean.

1982

"Landscape with Three Trees and Fence"

"Two Anemones in Blue Can"

"Two Roses in Glass Vase in Landscape"

(After you have seen York's art their spare titles allow you to see the paintings.)

"Carnations in Blue Can with Beetle in Landscape"
"Three Red Tulips in Landscape with Horse and Rider"
"Landscape with Man in Armor, Crocodile and Indian"
"Geranium in Blue Pot with Fallen Leaf and Bird"
"Bird with Dead Moth"
"An African Violet in Terracotta Pot in Landscape"
"Dandelions in Blue Tin"
"Landscape with Brown and Green Tree"
"Black Bull Standing in Landscape"

In 1982, at the age of 54, Albert York painted at least fifteen paintings, a big year for him. The painter Susan Rothenberg bought one of these, "Landscape with Three Trees and Fence." She said of York's art, "Each time he paints, he paints for the first time." No truer sentence about York has been written. Of the five Yorks Jacqueline Onassis owned, "Geranium in Blue Pot with Fallen Leaf and Bird" was painted in 1982. She bought her first York after Roy Davis pointed his work out to her during a visit she made to the Davis Galleries. Both the comic "Landscape with Man in Armor, Crocodile and Indian" and "Three Red Tulips in Landscape with Horse and Rider" date from 1982. A very good year for York.

He was using Windsor Newton paints, had been showing with Roy Davis for 19 years and would deliver his last painting to Davis ten years hence, facts that tell us nothing about this rich year. We know from Tomkins that York and his wife lived separately during 1982 and 1983 and that York had his dog for company in rented Long Island houses. It is during these years that York begins to put a vase with flowers

in a landscape, an interior world imagined outdoors. It is York putting the world, the landscape observed, remembered and returned to since his start as a painter, into a design that emphasizes what he brings to his vision of the Garden of Eden. The juxtaposition of flowers and landscape continue to startle, demanding—a pull not an order—the viewer adjusts to the scale. The roses, anemones and geraniums are bigger than trees and their various containers are large as dwellings. These still lifes have taken command, bringing a new order to the world around them. York painted many superb paintings, but in 1982 he was at his consistent best.

III

Woman and Skeleton

"The modern world just passes me by," York told Tomkins to explain why he felt his work to be out of step with his time, "I don't notice it. I missed the train." Perhaps this is why in "Woman and Skeleton" (c. 1967) the lively Father Time is so eager to get the attention of the young, nude woman primping her hair in a hand mirror. She seems determined to ignore her future as if the joke is really on him. This is a painting rich in humor, unlike the glum York eternally waiting at the station we might imagine from his conversation with Tomkins.

But York the painter is on a parallel track with his times. His paint handling is that of a painter who came of age in New York in the 1950s. His paintings surge with

the lavish, consciously beautiful lick of that moment in American art, and York's light—steady and luminous—are also of that moment. There is no question that York was on his own and not propelled along by whatever art world or historical forces were thought to be in motion over the past fifty years. He could never have fitted into Clement Greenberg's certainty about where art was heading. The Museum of Modern Art's white expanses were not built for paintings his size. He lived so decisively outside the art world of his time that he will not be found in poems, gossip or memoirs. He felt he had missed the train, but seen from the train his paintings are of the first rank. And so much that we thought hot, new and worth running to see now looks dated.

After the 2001 York retrospective at Davis & Langdale, I walked uptown holding in my mind as long as I could the Yorks I had just seen and the feeling (a mix of content and excitement) that they had given me. I drifted west and, in the 80s, began to walk toward the Met not really wanting to see anything that might interfere with my York reverie. Once in the museum I skipped the show I was intending to see, wandering toward the 20th Century American collection and the familiar rooms where Clyfford Still's paintings hang. I have never liked Still's work. His crags and peaks are not the Rockies, they're only made of clay . . . I don't see grandeur but American afflatus, the great ego and ambition of so much American painting after World War II. The train York missed was powered by big gusts of hot air.

Still's paintings hang alone, I recalled, by the painter's personal fiat, rigidly adhered to, that his paintings must be seen without the interference of other art. That afternoon Still's paintings had the affect of sharpening and clarifying the Yorks I had just seen. Size, not scale, means a great deal. Five or six Yorks hung in a large

museum room would be some sort of provocation, the beginnings of an argument. Size is one thing American art has been about for the past two centuries, and it has had all manner of implications, architectural and commercial. York is an artist who has joined profound, primary forms in a scale that makes his images large in the mind, larger than images ten times their size, an act as imaginative as any in 20th century American painting.

My favorite painting at the Met, the one I would make every effort to rip from the wall and carry to safety if the museum fire alarm went off, is Sassetta's "Journey of the Magi." It is about the size of thumbs meeting and hands held up to frame a scene, but in the mind the journey is forever. This is the company the best York paintings deserve to keep.

The train York missed is the one most of us want to be on, at least for part of the ride, the one that is *now*, full of life and energy. But it is not the only train. When you work alone, out of New York's civilizing and undermining rough and tumble, it must be easy to feel that you've missed what's going on. One of the beauties of York's art is that it was always on another track. You don't have to sort it out from the art of his times; it stands apart. His lineage is clear, Piero, Manet, Ryder—York could not hide it if he wanted to. (Roy Davis posits an additional, parallel lineage—William Blake, Samuel Palmer, Ryder, early Arthur B. Davies.) York's acts of attention were possible because he was as much in the past as the present. His art is not revolutionary and will never be seen as representative of or as any sort of key to his time. York's art is a law unto itself. York complained to Tomkins just like an artist who cannot be satisfied with what he has made complains, but his paintings do not complain. They are confident and have an innate dignity that never speaks of itself.

IV

York told Calvin Tomkins that the only real satisfaction he ever had as a painter was from a picture he painted of a young woman. He glimpsed her, arm or hand resting on a tree, during his first summer on Long Island. She was absorbed in looking at her garden and didn't see York, who, transfixed, memorized her pose. Later he returned to the scene following a fight with his wife about "finances," set down his paint box and painted the woman from memory. "Anyway," York finished his story with which Tomkins closes his profile, "I sat down and did the thing and it was one of the only things I really had satisfaction with." Roy Davis affirms that the painting is York's favorite.

The woman wears a white sleeveless dress and stands, her face partially obscured by the tree branch, her raised right hand holds onto or is pushing aside. The trees, brush really, at the edge of a field have been painted in quickly, so that the smudged leaves lack detail. There are white flicks of flowers in the knee-high grass. Behind the woman are fence posts. Her bright flesh draws the viewer's eye. Could she be playing a flirtatious hide 'n' seek? There's sexiness to her. If we hadn't known about the garden . . . but it isn't in the picture even if her half-hiddenness suggests an erotic exchange, at least a heightened, unresolved moment. Is she emerging from behind the branches or eavesdropping on a scene we can only imagine?

★ ★ ★

Albert York died in Southampton, New York on October 27, 2009. The following day Davis & Langdale published a notice of his death in *The New York Times*. This was followed by an obituary written by *Times* art critic Roberta Smith. The same obituary later appeared in *The Boston Globe* under the title "Albert York, 80, reclusive landscape painter." York's painting "Trees and Distant Hills, East Hampton" accompanied the obituary, as did a postage stamp size photograph of York.

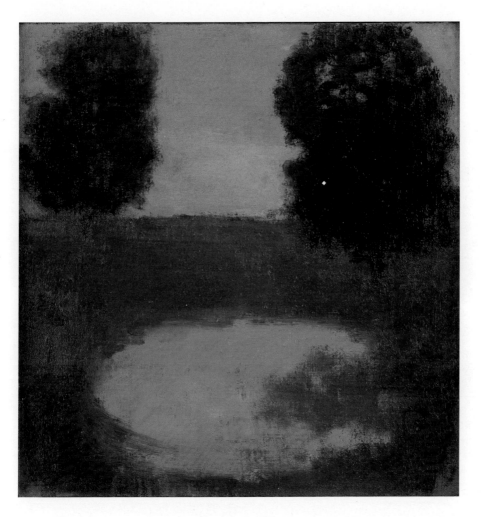

Twin Trees, c. 1963, oil on canvas mounted on masonite,
10 7/8 x 10 1/2 inches, Private collection

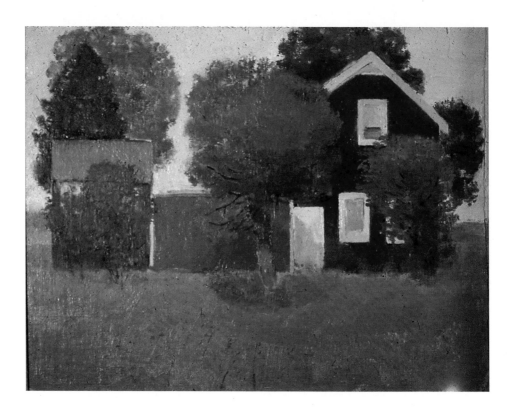

Farm House, East Hampton, c. 1964, oil on canvas mounted on plywood,
9 1/2 x 11 inches, Private collection

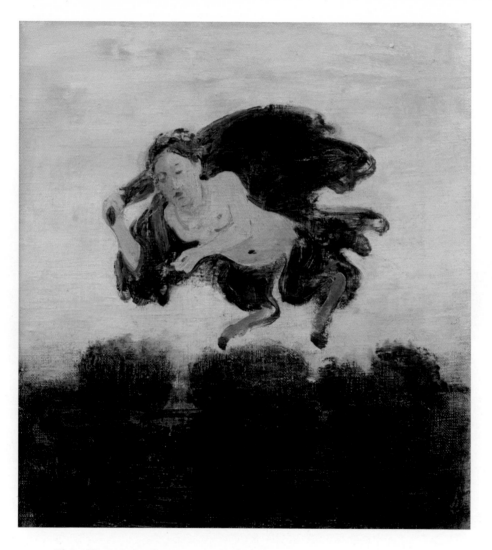

Flying Figure in Landscape, c. 1968, oil on canvas,
14 x 13 inches, Sheldon Memorial Art Gallery, University of Nebraska–Lincoln,
Gift of the American Academy of Arts and Letters, Hassam and Speicher Purchase Fund

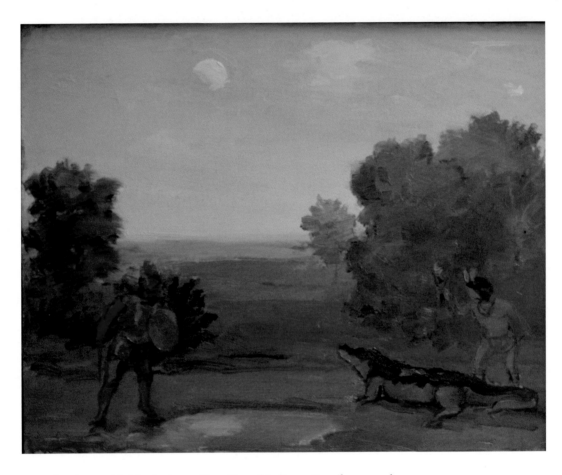

Landscape with Man in Armor, Crocodile and Indian, 1982, oil on wood,
11 1/2 x 14 11/16 inches, Private collection

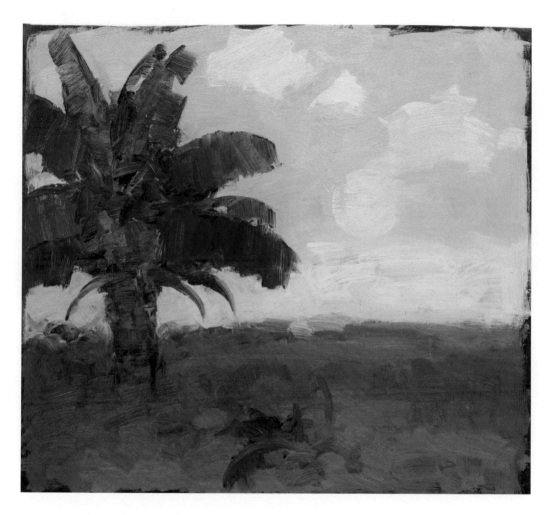

Moonlit Landscape with Palm Tree, 1990, oil on masonite,
10 3/4 x 12 5/16 inches, Private collection

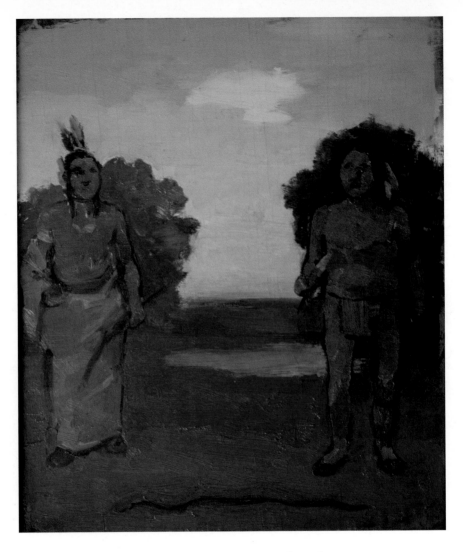

Landscape with Two Indians, 1978, oil on wood panel,
12 1/2 x 10 11/16 inches, Museum of Fine Arts, Boston

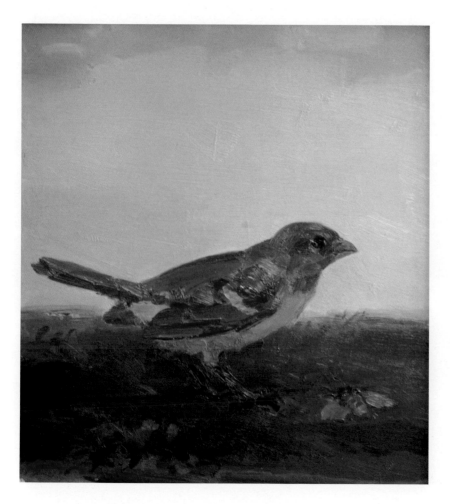

Bird with Dead Moth, 1982, oil on wood panel,
12 1/2 x 11 1/2 inches, Cleveland Museum of Art

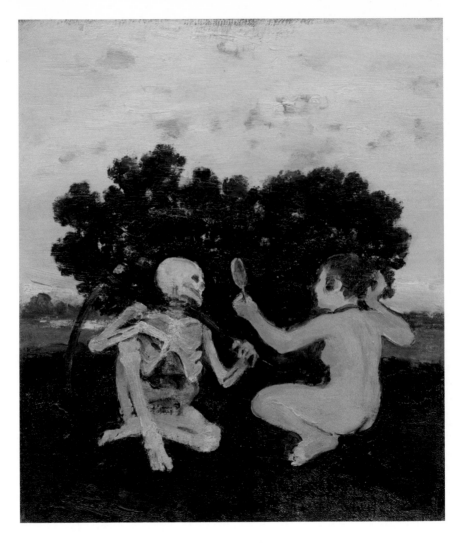

Woman and Skeleton, c. 1967, oil on canvas mounted on masonite,
12 x 11 inches, Private collection

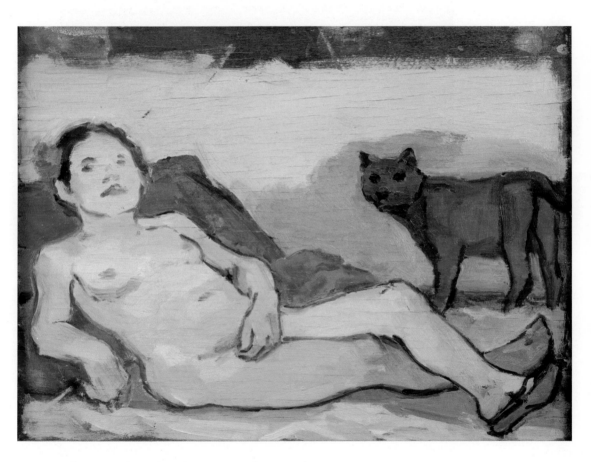

Reclining Female Nude with Cat, 1978, oil on wood,
9 3/8 x 12 1/2 inches, Private collection

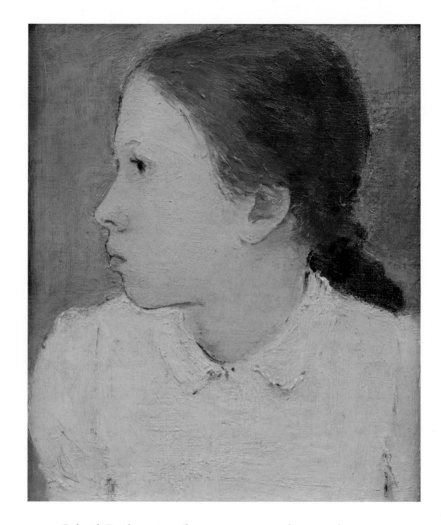

Girl with Braid, c. 1963, oil on canvas mounted on wood,
8 1/2 x 7 1/2 inches, Private collection

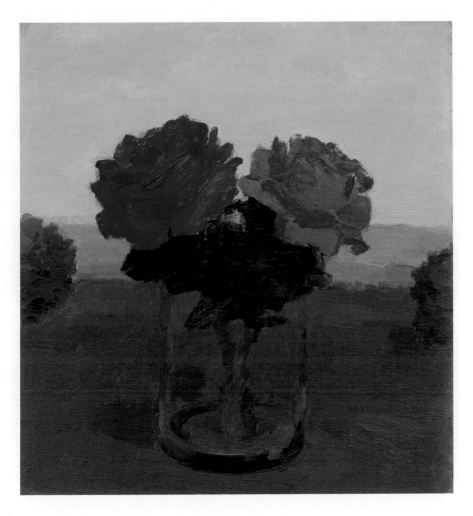

Two Roses in Glass Vase in Landscape, 1982, oil on masonite,
12 5/8 x 12 inches, Private collection

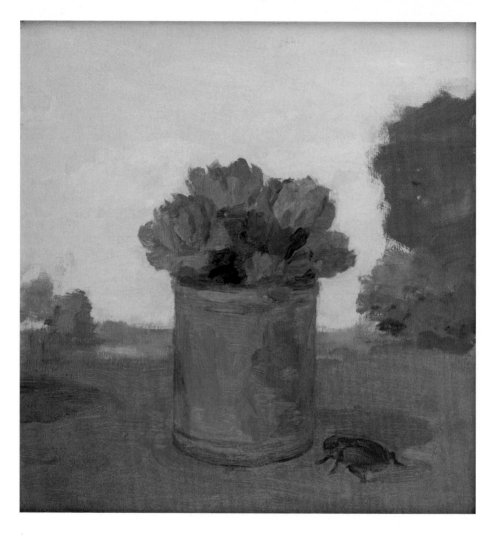

Carnations in Blue Can with Beetle in Landscape, 1982, oil on wood,
14 1/4 x 13 9/16 inches, Private collection

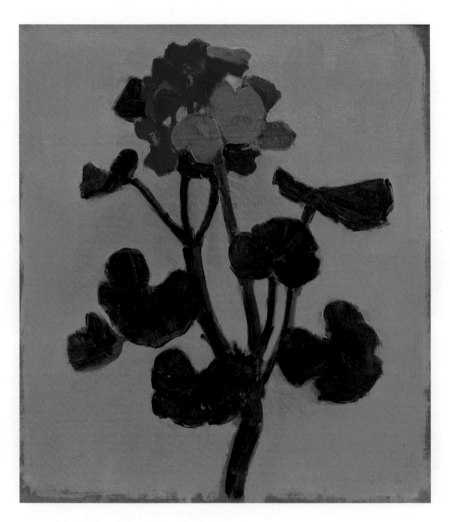

Geranium, 1975, oil on plywood,
12 x 11 inches, Private collection

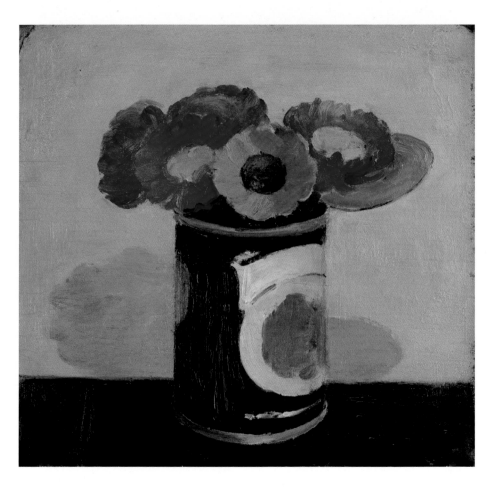

Red and Yellow Flowers in a Tin, c. 1966, oil on wood,
11 x 11 3/4 inches, Private collection

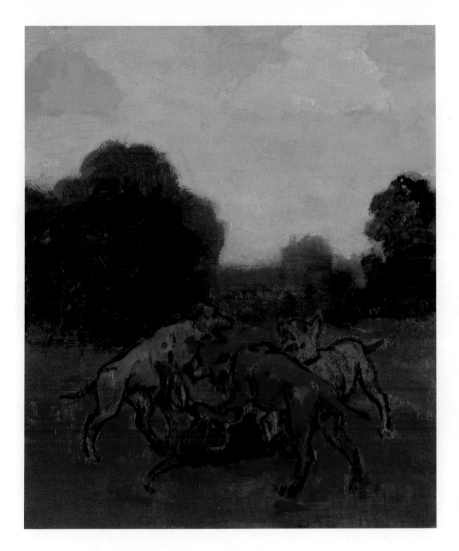

Four Dogs, 1977, oil on paper mounted on masonite,
11 5/8 x 10 inches, Private collection

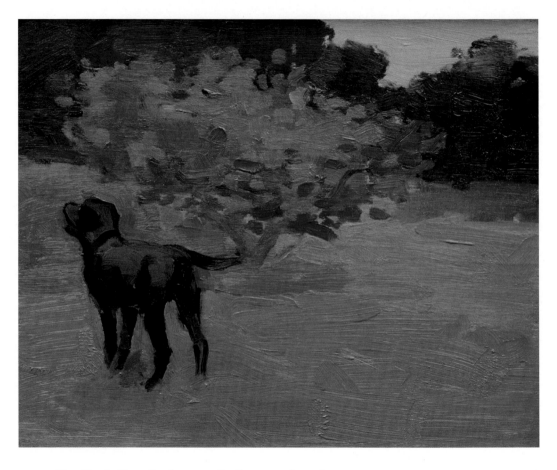

Grey Dog in Green Landscape, 1978, oil on wood panel,
9 1/2 x 11 7/8 inches, Private collection

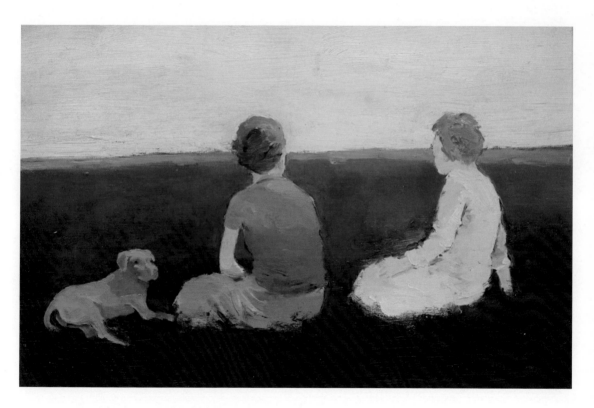

Late Afternoon, c. 1963, oil on plywood,
7 5/8 x 12 inches, Private collection

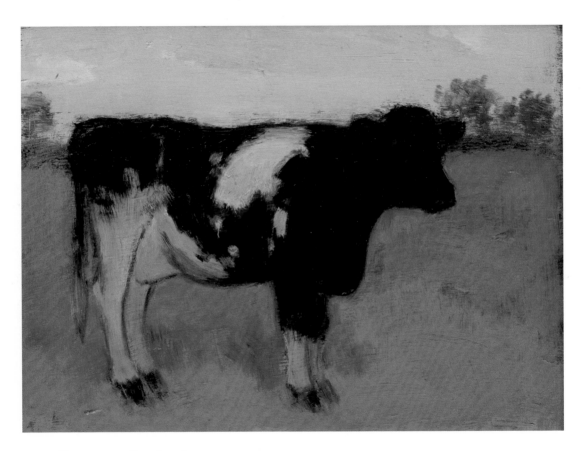

Cow, c. 1972, oil on board,
8 x 11 inches, Museum of Modern Art, New York, Gift of Werner H. Kramarsky

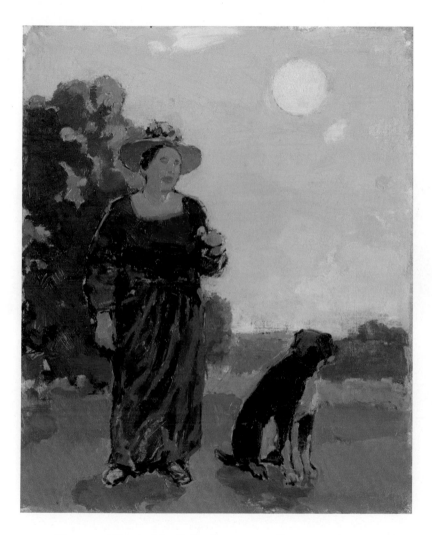

Woman and Dog in Moonlit Landscape, 1977, oil on masonite,
12 x 10 inches, Private collection

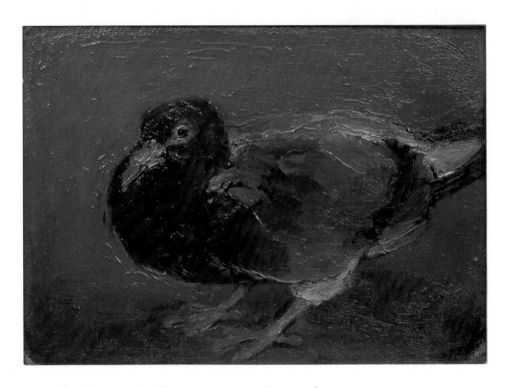

The Pigeon, c. 1963, oil on canvas mounted on wood,
7 1/8 x 10 inches, Private collection

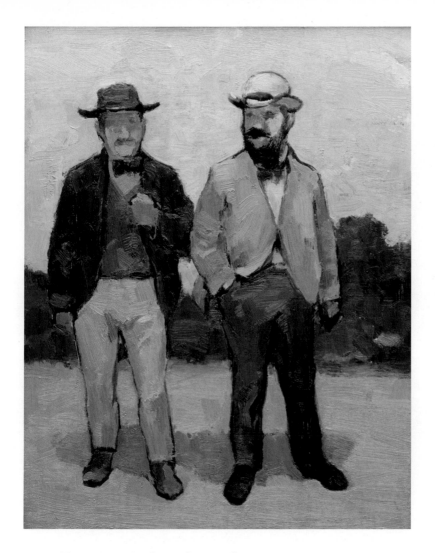

Two Men on Moonlit Road, 1978, oil on masonite,
12 x 9 3/4 inches, Private collection

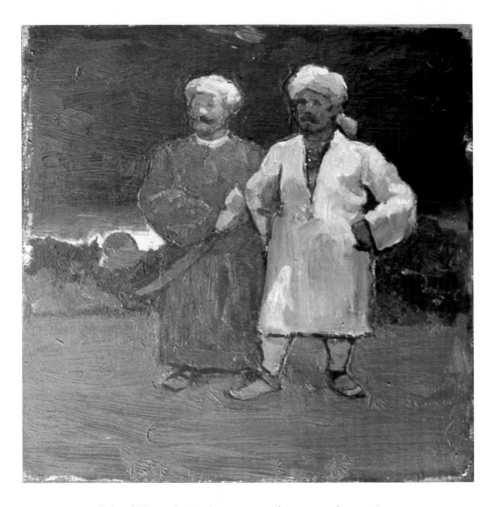

Oriental Figures in Landscape, 1977, oil on gessoed masonite,
10 x 9 1/4 inches, Private collection

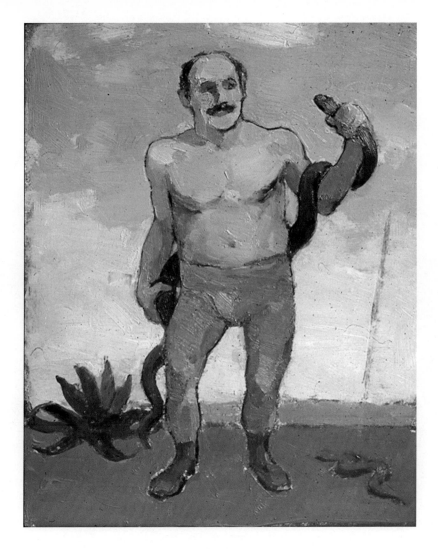

Man Holding Snake, 1977, oil on tin,
11 x 8 13/16 inches, Private collection

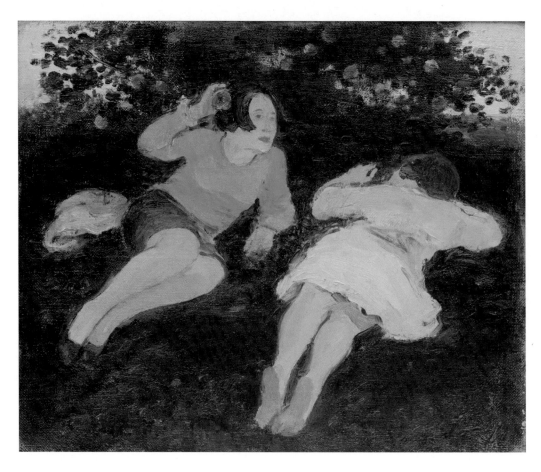

Two Reclining Women in Landscape, c. 1967, oil on canvas,
10 x 12 inches, Private collection

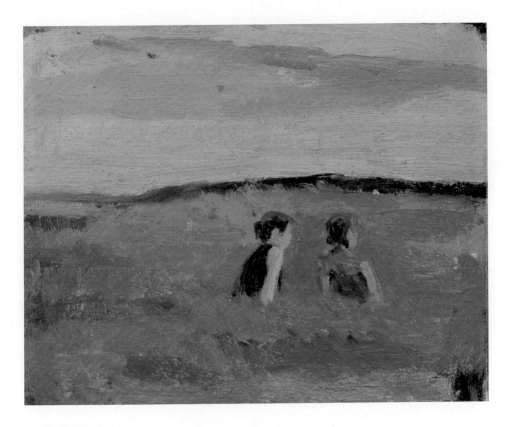

Figures in a Field, c. 1963, oil on canvasboard,
8 x 10 inches, Private collection

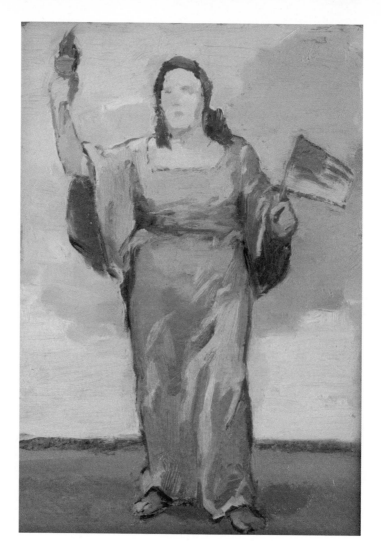

Liberty Figure, 1978–1979, oil on tin,
8 1/8 x 5 3/4 inches, Private collection

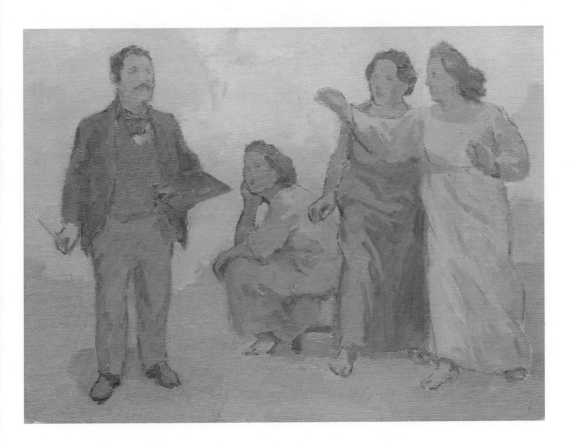

Artist with Three Muses, 1979, oil on canvasboard,
9 x 12 inches, Private collection

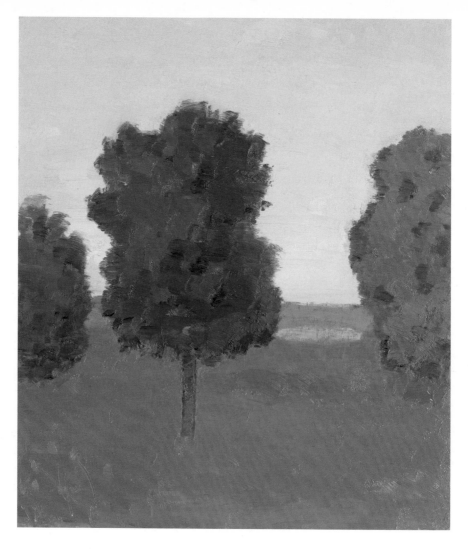

Landscape with Three Trees and Pond, 1985, oil on wood panel,
11 1/2 x 10 1/8 inches, Private collection

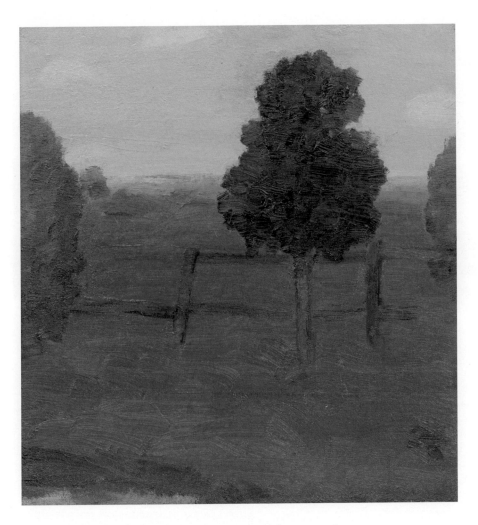

Landscape with Three Trees and Fence, 1982, oil on masonite,
11 7/8 x 11 1/4 inches, Private collection

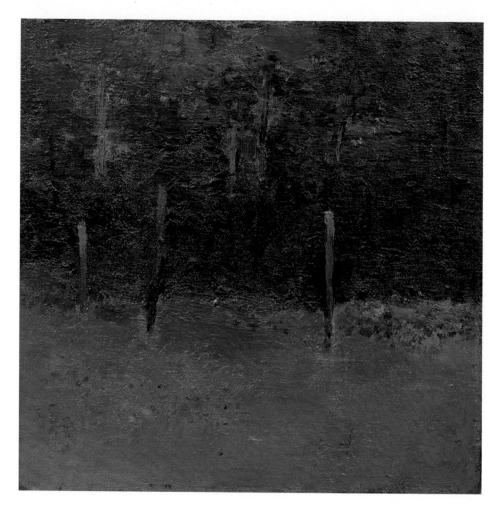

Edge of the Forest, c. 1963, oil on canvas mounted on masonite,
10 1/2 x 10 3/4 inches, Private collection

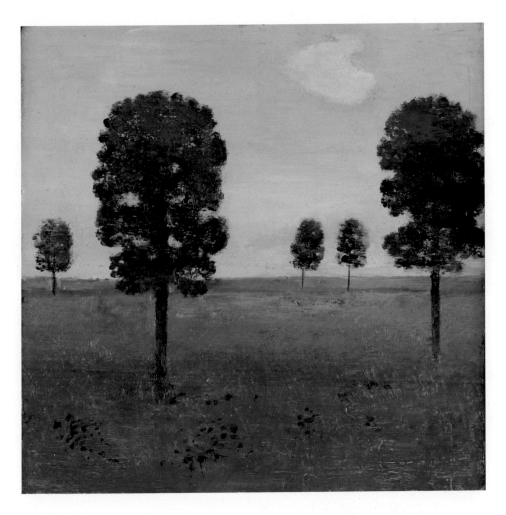

The Meadow, East Hampton, c. 1963, oil on canvas mounted on masonite,
10 x 10 inches, Private collection

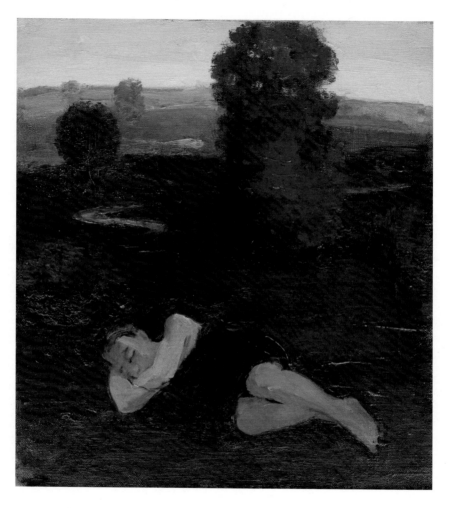

Landscape with Sleeping Figure, c. 1968, oil on canvas,
13 7/8 x 12 7/8 inches, Private collection

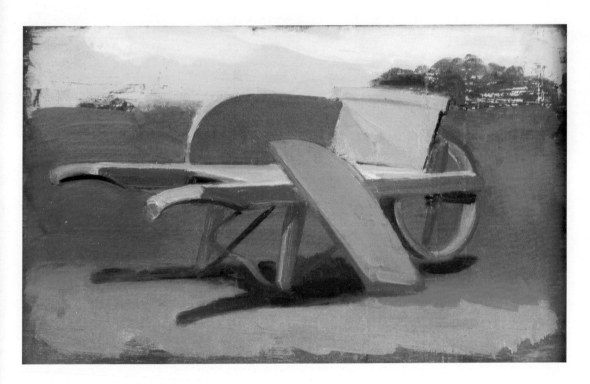

Wheelbarrow, 1974, oil on wood,
6 7/8 x 11 3/16 inches, Private collection

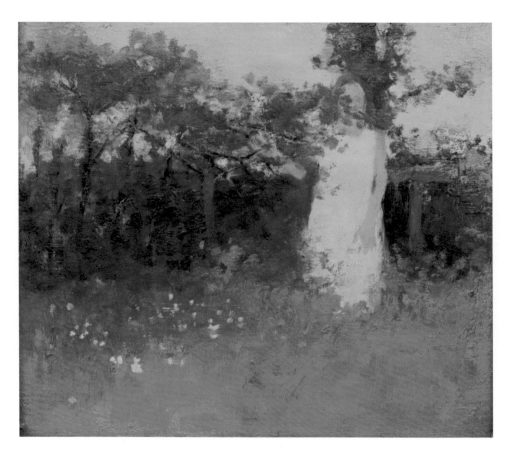

Spring, c. 1963, oil on canvas mounted on masonite,
9 x 10 1/4 inches, Private collection

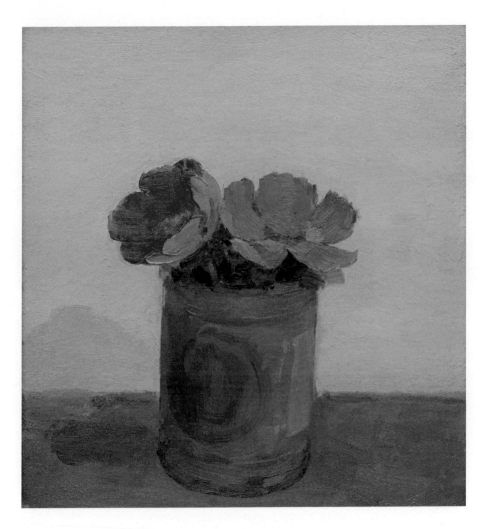

Two Anemones in Blue Can, 1982, oil on masonite,
13 x 11 7/8 inches, Private collection

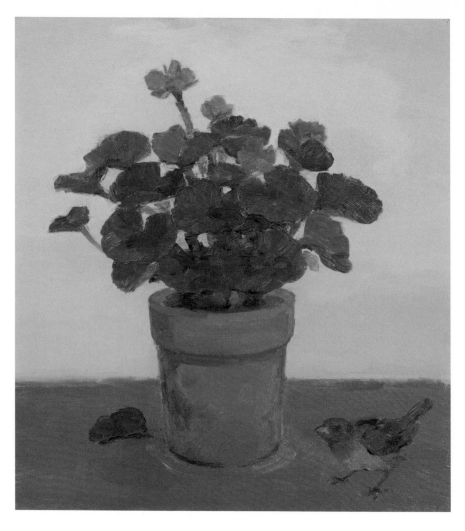

Geranium in Blue Pot with Fallen Leaf and Bird, 1982, oil on wood panel,
18 x 16 15/16 inches, Private collection

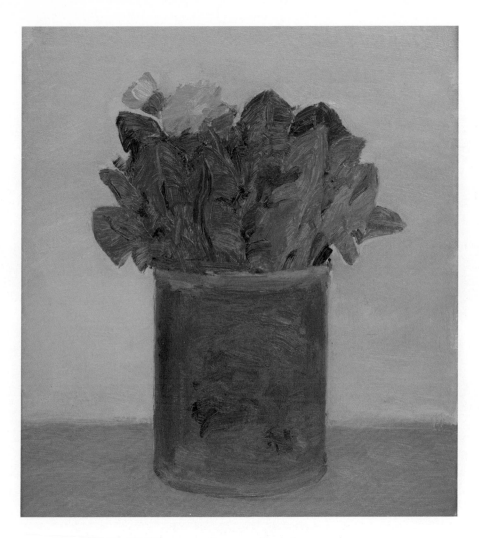

Dandelions in Blue Tin, 1982, oil on wood panel,
12 x 10 3/4 inches, Wadsworth Atheneum, Hartford

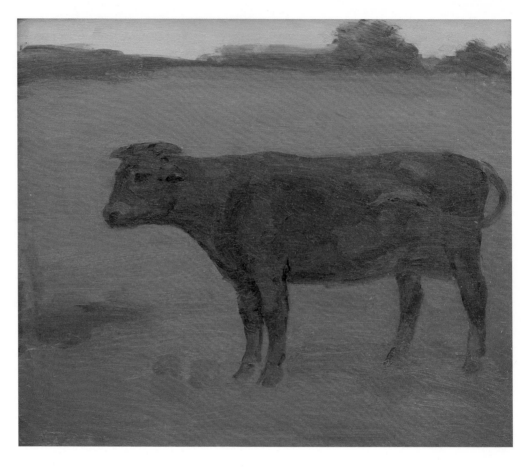

Black Bull Standing in Landscape, 1982, oil on wood panel,
11 1/2 x 13 7/16 inches, Private collection

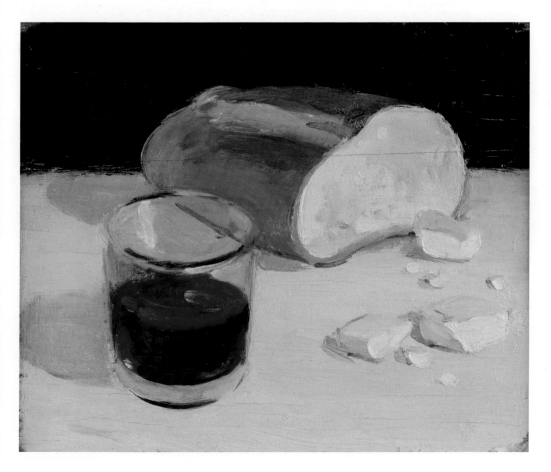

Bread and Wine, c. 1966, oil on wood,
8 x 9 3/4 inches, Private collection

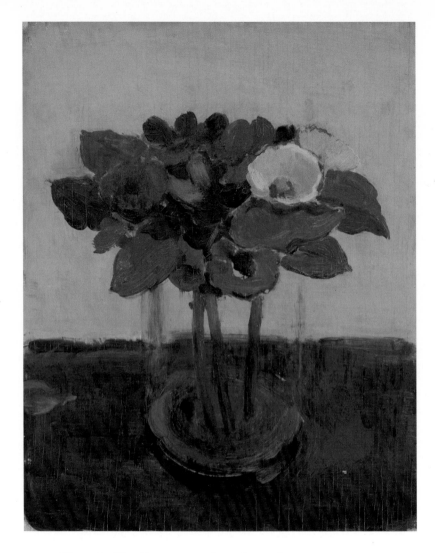

Flowers in Glass Vase, c. 1971, oil on plywood,
10 1/2 x 8 3/8 inches, Private collection

Appendix: Robert Grosvenor's Idea

The sculptor Robert Grosvenor owns three Yorks, two of which he bought in the 1980s. In response to a letter from me about his York's Grosvenor wrote, "Yes, our 3 Yorks are unframed—sometimes I put them on narrow shelves or else support them by four pins. They look better on a shelf leaning against the wall. They can be so easily moved, no confining frame, no hidden nails. They're just there as I think York might have looked at them. I take them with me as I miss them when they're not around.

Did (does) York want them to be picked up, taken home by the viewer? I like to think so."

I could have asked Cecily Langdale to forward Grosvenor's query to York. But I decided not to. I like Grosvenor's idea and do not want to hear that York had no such intention, that he just didn't feel like framing his paintings. Whatever York's attitude was toward frames, Grosvenor is right about the viewer, this one at least, wanting to hold York paintings. I got to do this once, holding and soaking in every inch of the paintings Wynn Kramarsky then owned. I will not forget how—I haven't been able to come up with the exact word for what I felt—how "comforting" they looked up close.

"One York painting I think about, never seen in reproduction," Grosvenor ended his letter, "is the head of a woman from the back with a plume or feather standing vertically—maybe supported by a headband or turban. Very mysterious and compelling."

Thank you

This book benefited from the help given by
John Baker
Bill Berkson
Beverly Corbett
Roy Davis
Robert Grosvenor
Robert Hershon and the editors of *Hanging Loose*
Wynn Kramarsky
Evelyn Kroenlein
Cecily Langdale
Nina Nielsen
Susan Scott
Calvin Tomkins
Susan Jane Walp
Ben Watkins
Trevor Winkfield and Brice Brown of *The Sienese Shredder*
Karen Wright of *Modern Painters*

I thank you one and all.
 W.C.

Essay Copyright © 2010 by William Corbett

typeslowly designed

Printed by Friesens in Canada

Cover: *Three Red Tulips in Landscape with Horse and Rider*, 1982, oil on wood, 15 3/8 x 14 1/4 inches, Collection of the Parrish Art Museum Southampton, New York, Gift of Mr. and Mrs. Werner H. Kramarsky

Frontis: *Self-Portrait with Head of a Dog*, April 1979, charcoal on paper, 24 x 19 inches, Private collection

First printing in 2010

ISBN 978-0-9824100-5-9

Pressed Wafer / 9 Columbus Square / Boston, Mass. 02116